OPEN ME ...

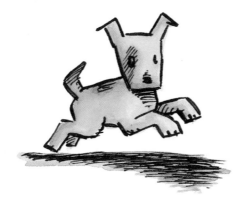

For Dash and Nadja

art spiegelman
I'M A DOG!

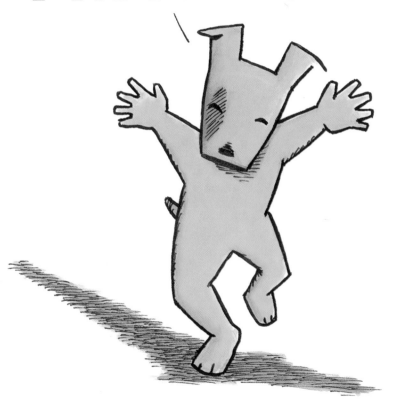

JOANNA COTLER BOOKS
An Imprint of HarperCollinsPublishers

What's that?

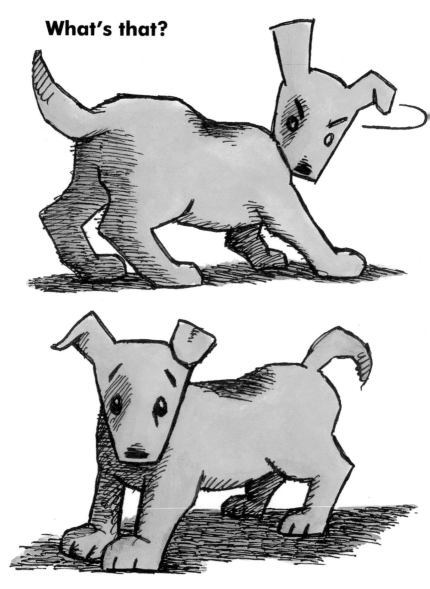

You think I smell of paper and ink?!

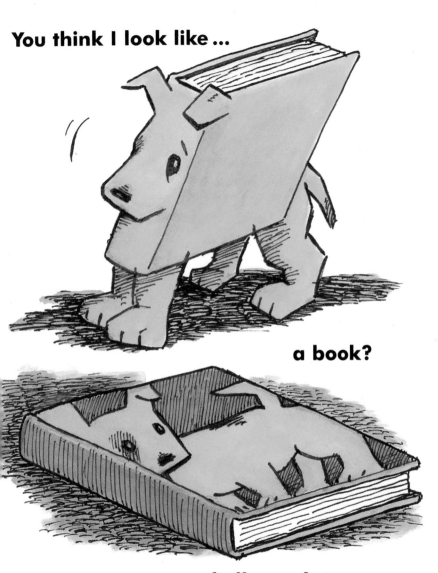

Look!
I can wag my tail.

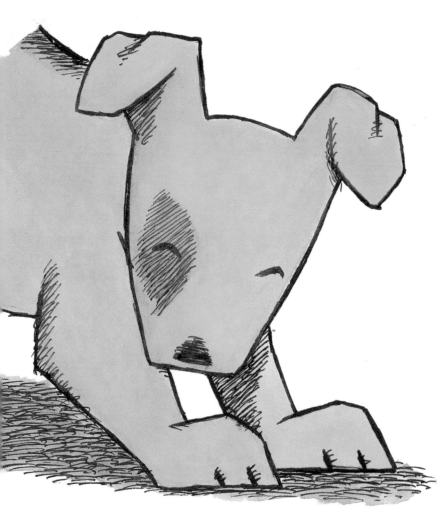

How many books have tails that wag?

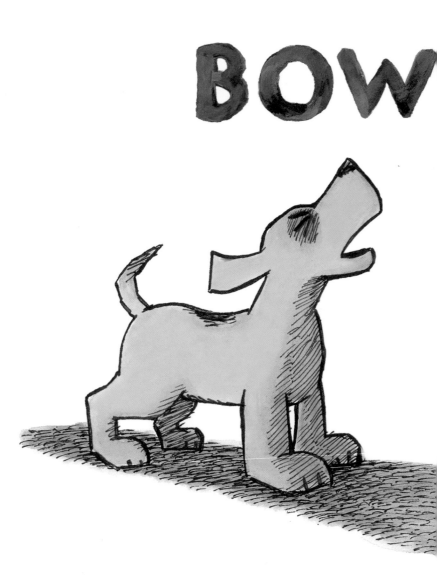

BOW

WOW!

Did you ever hear of
a *book* that could bark?

WAIT! Don't put me back on the shelf! I'll tell you about the wizard's curse.

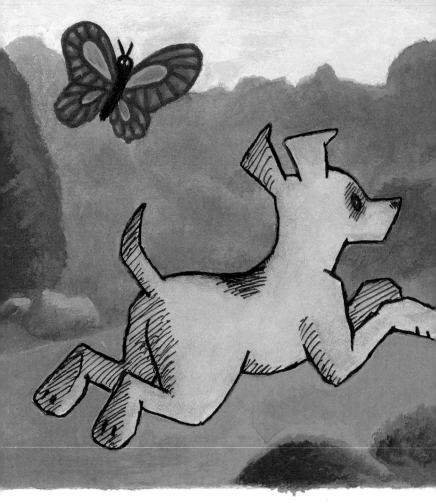

It started when I was just a pup...

A rabbit drove by, so of course I chased it.

I got lost somewhere
in an enchanted wood.

I was found by a witch.
She smelled like oatmeal.

She was nice for a witch, until I chewed up the handle of her very best broom.

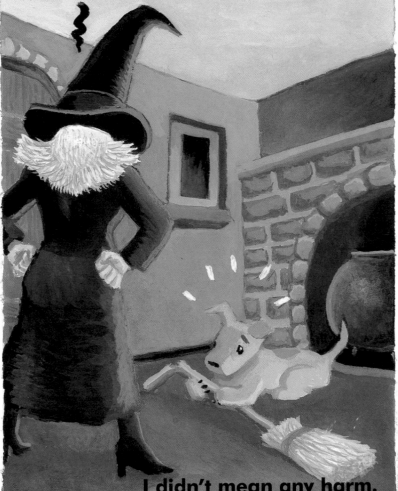

I didn't mean any harm.
I was just a pup and my teeth itched.

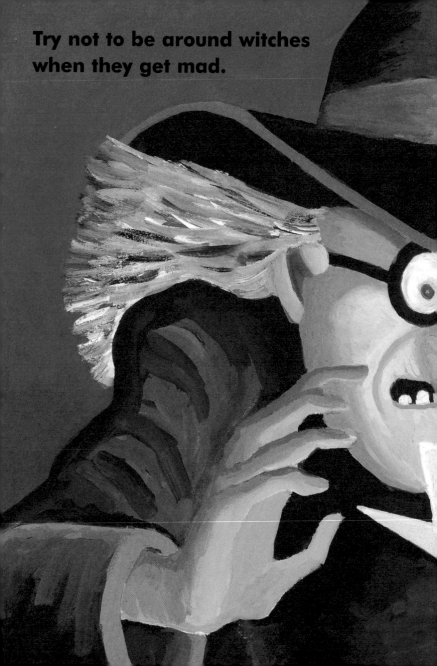
Try not to be around witches
when they get mad.

My witch got terribly temper-tantrum mad! She said some things I can't repeat, and she turned me into ...

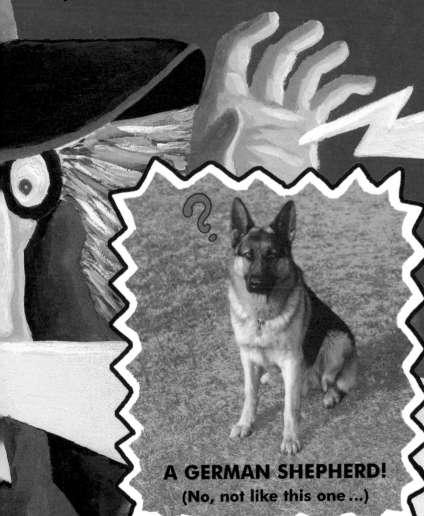

A GERMAN SHEPHERD!
(No, not like this one ...)

She turned me into a *real* shepherd, on a mountaintop in Germany.

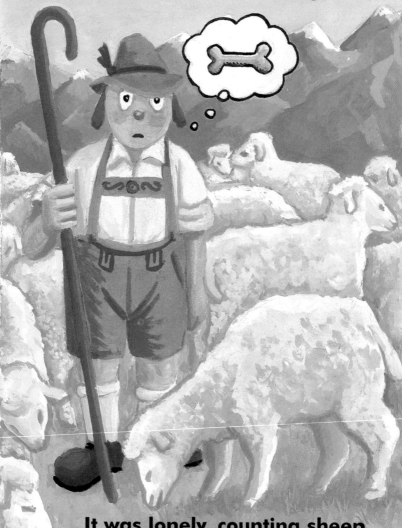

It was lonely, counting sheep.

Then I met Magda, the magic maiden of the mountain.

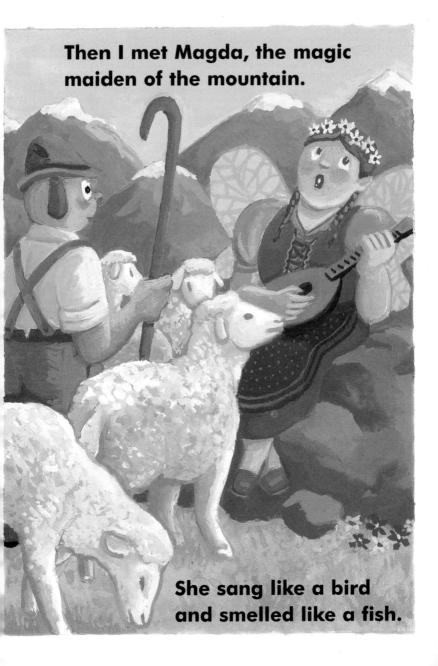

She sang like a bird and smelled like a fish.

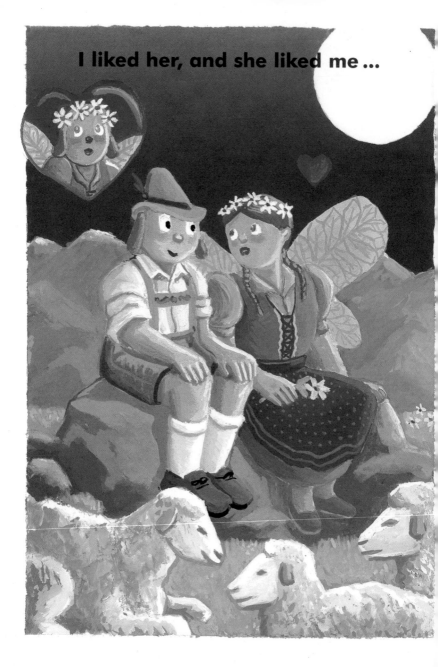

Magda thought I was teasing her.
She got *triple* temper-tantrum mad.

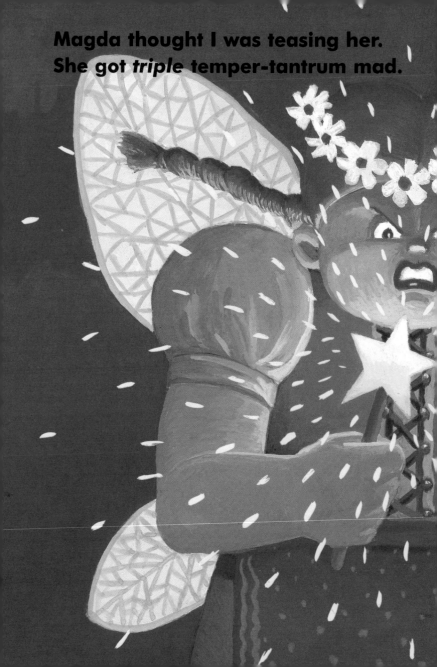

She said some things I won't repeat,
and she turned me into ...

A BULLFROG!
(Bigger than this one ...)

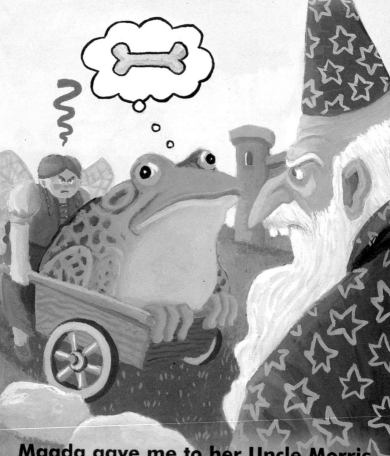

She turned me into
a frog the size of a bull!

Magda gave me to her Uncle Morris
as a gift. He was an evil wizard who
wanted to use me in a magic stew.

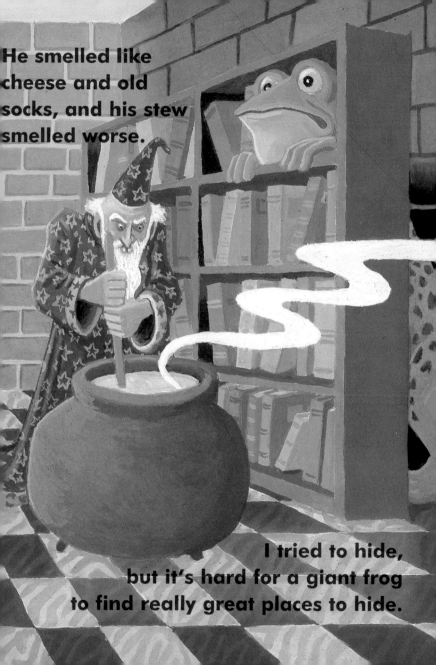

He smelled like cheese and old socks, and his stew smelled worse.

I tried to hide, but it's hard for a giant frog to find really great places to hide.

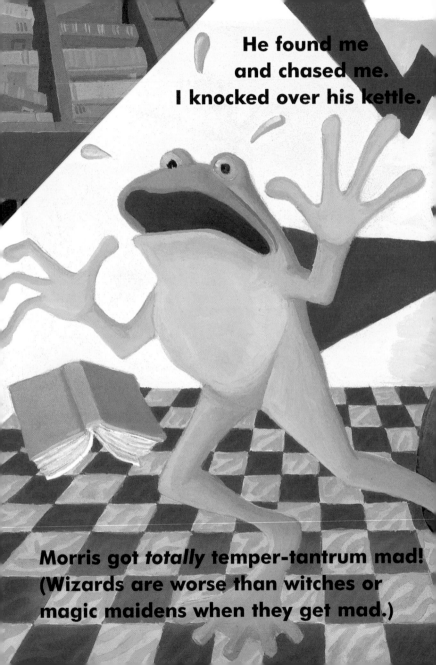

He found me
and chased me.
I knocked over his kettle.

Morris got *totally* temper-tantrum mad!
(Wizards are worse than witches or
magic maidens when they get mad.)

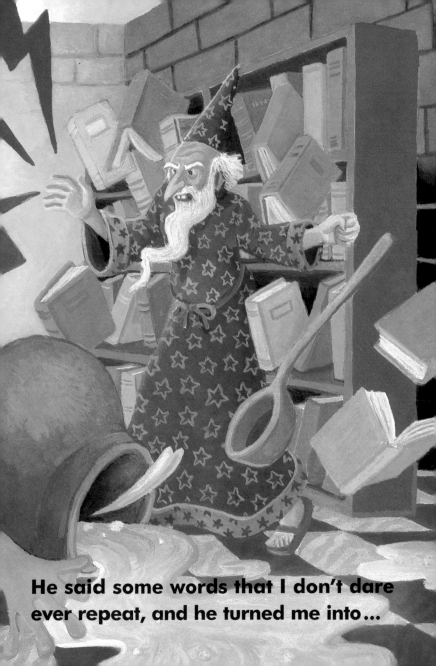

He said some words that I don't dare ever repeat, and he turned me into...

... this book!

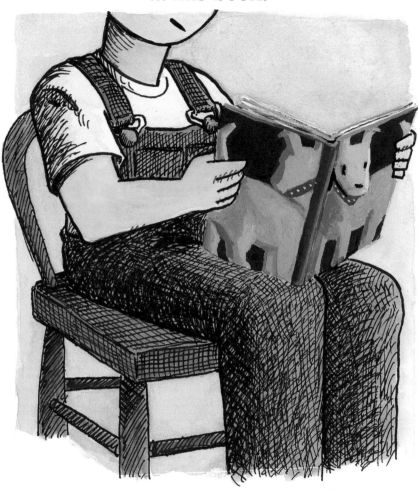

**But I'm not a shepherd,
I'm not a big frog,
and I am certainly not a book!**

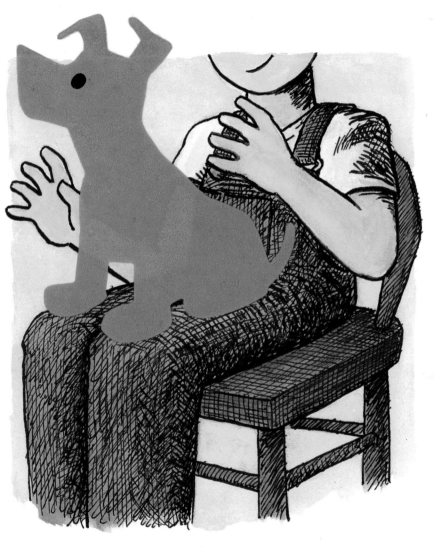

I love sitting in your lap,
but I want you to *pet* me,
not just turn my pages!

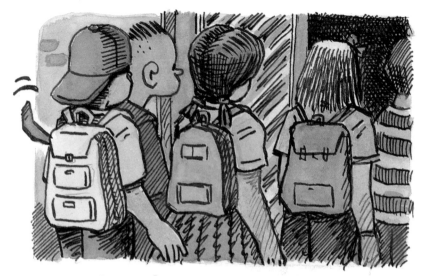

**I can be your special pal
and sneak into school with you.**

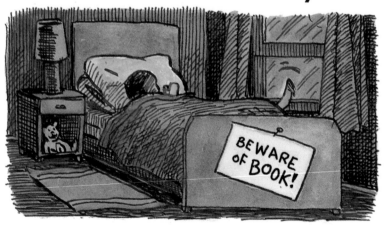

**I can sleep by your feet,
and keep you safe while you dream.**

Hey! Let's go to the park. We can watch other dogs chase sticks.

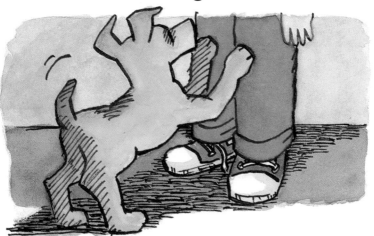

I may not run as fast as they do ...

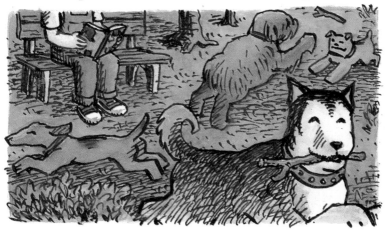

but at least I don't have fleas and I *never* bite.

If you forget to walk me, I *promise* not to make a mess on the carpet.

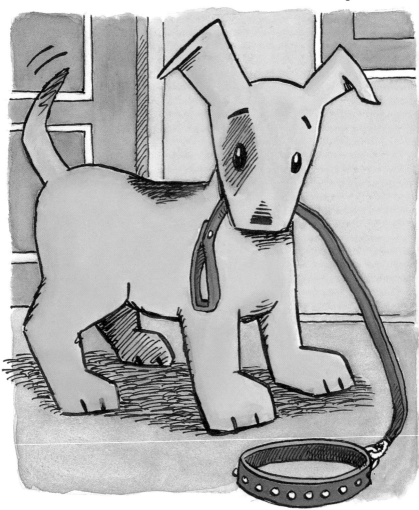

Just believe me. I AM a dog.

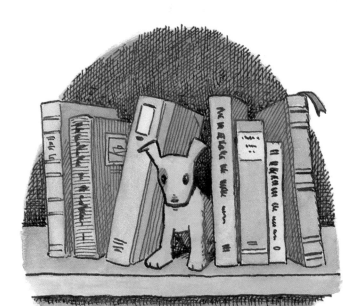

If you let me be *your* dog
I'll tell you my story
whenever you like!